MIES JULIE

Yaël Farber's

MIES JULIE

RESTITUTIONS OF BODY & SOIL
SINCE THE BANTU LAND ACT NO. 27 OF 1913
& THE IMMORALITY ACT NO. 5 OF 1927

Based on August Strindberg's *Miss Julie*

OBERON BOOKS
LONDON

WWW.OBERONBOOKS.COM

First published in 2012 by Oberon Books Ltd
521 Caledonian Road, London N7 9RH
Tel: +44 (0) 20 7607 3637 / Fax: +44 (0) 20 7607 3629
e-mail: info@oberonbooks.com
www.oberonbooks.com

Reprinted in 2012, 2013 (twice), 2015

PB ISBN: 978-1-84943-489-8
E ISBN: 978-1-84943-761-5

Cover image by Murdo Macleod

Printed and bound by 4edge Limited, UK

Visit www.oberonbooks.com to read more about all our books
and to buy them. You will also find features, author interviews and
news of any author events, and you can sign up for e-newsletters
so that you're always first to hear about our new releases.

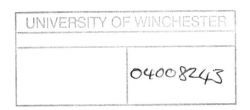

My gratitude to:

Lara Foot

The cast who originated these roles.

The entire team at The Baxter Theatre Centre, Cape Town.

Jonathan Garfinkel; Tanya Farber and Aubrey Sechabe.

The Farber-Daniel family for their support during the creation period

and

Ella Altidor – for bearing the upheavals in your little world.

Mies Julie was commissioned and originally produced by the Baxter Theatre Centre at the University of Cape Town, and premiered at the National Arts Festival, Grahamstown, South Africa, on July 8, 2012 with the following cast:

Mies Julie	Hilda Cronje
John	Bongile Mantsai
Christine	Thoko Ntshinga
Ukhokho	Tandiwe Nofirst Lungisa

Director	Yaël Farber
Music composed & performed by	Matthew & Daniel Pencer
Singer & musician	Tandiwe Nofirst Lungisa
Set design	Patrick Curtis
Costume design	Birrie le Roux
Lighting design	Paul Abrams
Sound design	Philip Botes

Mies Julie premiered in the United Kingdom at the Assembly Hall in Edinburgh on August 9, 2012.

Mies Julie premiered in North America at St. Ann's Warehouse, Brooklyn, NY, on November 8, 2012.

Mies Julie	Hilda Cronje
John	Bongile Mantsai
Christine	Thoko Ntshinga
Ukhokho	Tandiwe Nofirst Lungisa

Director	Yaël Farber
Music composed & performed by	Matthew & Daniel Pencer
Singer & musician	Tandiwe Nofirst Lungisa
Set design	Patrick Curtis
Costume design	Birrie le Roux
Lighting design	Patrick Curtis
Sound design	Philip Botes

'Awaking on Friday morning, June 20, 1913,
the South African Native found himself, not actually a slave,
but a pariah in the land of his birth.'

Sol Plaatje

Characters

MIES JULIE
Afrikaans daughter of a farmer, early 20s

JOHN
Xhosa man, a servant on the farm, late 20s

CHRISTINE
Xhosa woman, mother to John, a domestic
worker on the farm who raised Julie, mid-60s

UKHOKHO
Xhosa woman, other-wordly ancestor of
indeterminate age

SETTING
A farmhouse kitchen.
Eastern Cape – Karoo, South Africa.
Freedom Day 2012

MISE EN SCENE

The kitchen is defined simply by an oxblood-coloured floor, which sits like an island in the centre of the endless planes of the Karoo's bleak beauty. Downstage right, the floor's stone tiles are ruptured by a truncated tree stump and its surrounding roots – which protrude and have spread along the floor. There is: a kitchen table and chairs; a stove on which a pot smoulders with steam; a small bench that John sits on to polish boots; a larger bench lined with rubber gumboots and rough farming implements (sickle, panga/machete, pitchfork, spade, sheering scissors). A birdcage hangs upstage right, just outside of the defined kitchen area. Its shape should resemble a small house. A large pair of lace-up leather boots stands alone. Their power is obvious.

A fan circles slowly, listlessly overhead.

UKHOKHO is always present on the periphery, watching. At times she enters the kitchen space when indicated. At other times, she returns to her observer stance – a discreet presence on the periphery.

1.

Night. The heat is stifling.

CHRISTINE is on all fours, scrubbing the stone floor. She is sweating profusely. She sings a circular phrase – a soft atonal moan from a church spiritual. She periodically scrapes an enamel bucket along the floor so that it remains by her side as she cleans. JULIE enters and walks circles – aching with boredom and loneliness. She sits at the table, her feet up. She rises and walks across the floor – leaving footprints. CHRISTINE follows behind and erases them without a change of expression. JULIE disappears into the night. JOHN stands at the door, watching his mother, who continues her work unawares. He has a large 'throw' about his neck and shoulders.

JOHN: *(Watching where she left.)* She's mad again tonight, ma. Bewitched.

 Looking out across the night sky.

 It's a dark night. Where's this moon? Supposed to be full.

CHRISTINE: The swallows are flying low. We'll have rain after midnight – when this heat breaks.

JOHN: *(To himself.)* Ja[1]... Dangerous. Coming to our party like that.

CHRISTINE: Poor baby. She's been wild since Baas[2] Jan broke off the engagement.

 CHRISTINE goes to the stove and brings JOHN a plate of food. They bow their heads and pray.

1 **Yes** *(Afrikaans)*
2 **boss** *(Afrikaans; a term not always specific to an employer but indicates subservience on the speaker's part.)*

JOHN: Salt?

CHRISTINE: Hayi kaloku![3] Taste first.

He tastes and indicates for the salt. She hands it to him with playful annoyance. He adds generously. She snatches it away. He moves to his bench, and sits. He eats.

Indicating a chair at the kitchen table.

You can sit to eat. Meneer[4] is away.

He glances about – then moves to the table, sits and eats.

CHRISTINE is peeling potatoes now.

JOHN: *(Looking towards the stove.)* What's that stink?

CHRISTINE: It's for Julie's dog, Diana.

JOHN: You have to cook for her dog now too?

CHRISTINE: She's pregnant. Miesie[5] wants me to take care of it. The bitch was in heat last month and all the pedigree dogs from around here wanted her.

JOHN: I heard them howling. I thought it was just the moon.

CHRISTINE: But our Swartkop got her. Klein Mies[6] was furious. She says the dog betrayed her. *(Stirring the foul fluid.)* She asked me to prepare something that will kill the puppies in the womb.

3 **Taste first!** *(isiXhosa)*
4 **Mister** *(Afrikaans; a title indicating subservience towards the subject on the part of the speaker.)*
5 **miss** *(Afrikaans; a term of respect that indicates subservience on the speaker's part.)*
6 **little miss** *(Afrikaans; a term of address used by black South African employees when referring to the children of their white employers.)*

JOHN: *(To himself.)* Mies Julie… She's dancing wild out there with our boys – but she won't let her bitch touch ours. She's like all white women. Too proud. But not proud enough. Maybe she'll blow her brains out – like her mama.

CHRISTINE: Haai![7] I don't want such talk in my kitchen. I want you to go get her and bring her back here.

JOHN: I'm still eating, ma.

CHRISTINE folds her arms and stares at her son.

The new boys were asking how come you can you cook for me in here – and they're out there with no electricity or water.

CHRISTINE: This is *my* kitchen. They will never understand how things work around here. They come to Veenen Plaas[8] and want to take what we've been working for all our lives.

JOHN: When winter comes – our children will freeze. Meneer refuses to turn the heat and water back on until we chase the squatters away. It's a brutal way. Punishing *us* to get them off the land.

CHRISTINE: They must build their shacks somewhere else. Meneer doesn't want them living here.

JOHN: He's a hard boer[9]. By law they have the right to live here – if their parents did. A storm is coming to this farm. The workers are celebrating Freedom tonight, but there is anger on the wind out there.

7 **Hey!** *(vernacular)*
8 **The Weeping Farm** *(Old Dutch; the name of the farm)*
9 **farmer** *(Afrikaans)*

CHRISTINE: This is Meneer's land. He decides. Finished and klaar[10].

JULIE enters the kitchen. JOHN stands immediately – caught in the forbidden act of sitting at the family table. But JULIE paces, preoccupied. JOHN finishes eating on his feet, and then goes to his bench to polish the Meneer's boots. CHRISTINE stirs the concoction at the stove. Mother and son surreptitiously watch JULIE , who is unaware of their gaze.

CHRISTINE: Rain coming tonight Miesie. I can smell it.
The ants are moving faster. The clouds gathering low.

JULIE doesn't respond. She lies back, full length, on the kitchen table.

I'll go give this to Diana.
It won't be easy on her. The pregnancy's too far already.

But I'll do my best.

She strokes JULIE's hair and then goes out, looking for the dog.

JOHN removes the 'throw' from his shoulders and drops it to the floor. He begins polishing the Meneer's boots. Nothing for sometime but JULIE – who rises and paces – and John working at the boots. JULIE is restless, preoccupied, wanting. JOHN watches her when she cannot see him.

When she can, he is inscrutable in servitude.

JULIE: I was looking for you.

JOHN: *(Stands.)* Do you need me, mies?

JULIE: Come back to the party and dance.

10 **finished** *(Afrikaans; 'finished and klaar' is a South African expression, connoting 'end of discussion')*

JOHN: Don't go back there looking for trouble, mies.

JULIE: Niemand sal aan my raak nie.[11] My pa will shoot the black man in the head that puts his hands on me. Then he'll shoot me. Told me that once when I was little. That was my bedtime story. *(She laughs.)*

Come. Dance with me.

JOHN: You drunk, Mies Julie. Go to bed.

JULIE: Scared?
Don't worry. My father wouldn't touch you. You're his favourite. Likes you more than he ever liked me. Always wanted a boy.

She looks away, out into the night.

It's dry out there. Bleached yellow white. This time of year always reminds me when I was a kid. You know. After my ma. The open veldt[12] fires. She used to come home from her midnight walks – her hair smelling like wood smoke and burnt leaves. Smells like my ma out there.

He continues his work in silence.

What's your problem? It's just dancing.

JOHN: Don't try be one of us tonight, Mies. They're celebrating with anger out there. I can't protect you like before. Just go to bed.

JULIE: We cannot have the squatters build their shacks on our land…

11 **No one will touch me.** *(Afrikaans)*
12 **field** *(Afrikaans)*

But I don't agree with how my father is doing it. I'm not like him, you know.

He does not respond.

Christine will never forgive you – if something happens to me out there. Your mama will punish you if I get hurt. Just like she used to when we were small.

She backs out the door, daring him. JOHN sits alone for a while, cleaning the boots. He stops and stares ahead. He is filled with anger and desire for her. Kwaito music[13] drifts in and out on the wind. He stands and paces the kitchen. He suddenly dances alone. He walks out into the night, towards the music.

The kitchen stands empty. A low electronic hum begins, as UKHOKHO rises from where she has been watching. Softly playing her harmonica, she walks the periphery of the kitchen. CHRISTINE, humming to herself, returns with the empty dog plate. She moves into the kitchen and immediately senses the presence of her ancestor. She drops the plate with a clatter. She is frozen – staring trance-like.

JOHN enters and moves swiftly to his mother.

JOHN: Ma, you alright?

CHRISTINE: Ndiyamva.[14] She is here again, son.

JOHN: Who, ma?

CHRISTINE: When she's restless, I can smell her.

I can smell the damp.

JOHN is silent with grave concern, watching his mother.

13 *A variant of house music that emerged in Johannesburg, South Africa in the 1990s. It remains most popular amongst the black youth of South Africa.*

14 **She is here again, son** *(isiXhosa)*

I've told her: Ndimxelele Ukhokho![15] You must rest now. Eat soil and be quiet. Meneer will throw me off Veenen Plaas if I break the floor again. Don't disturb my head. She just laughs and shows me where the roots of the tree are cracking through these stones.

JOHN: Did you faint again, ma?

On her knees, her hands running over the tree's roots.

CHRISTINE: I used to play in this tree when I was a girl. Before this farmhouse was built. When there was nothing here but open veldt.

JOHN: That wasn't you ma. That was your grandmother. Remember? When you were born – this house was already here.

CHRISTINE: Kuthe Thabalala.[16] And this tree belonged only to the wind.

JOHN: Ma –

On her knees, patting the kitchen floor.

CHRISTINE: Our ancestors are all buried in this field. But when the Meyers built this house, they cut the tree down and laid a kitchen over the graves.

JOHN: Don't talk about this in front of Meneer, ma.

CHRISTINE: After the madam died, they tore up the kitchen floor. The roots were still alive in the concrete. Fat and wet and full of the earth's blood under those old tiles.

15 **Rest, ancestor!** *(isiXhosa)*
16 **Just open land.** *(isiXhosa)*

JOHN: Ma, sukuthetha ngezizinto.[17]

CHRISTINE: That tree was here before any of us. We planted it over your great grandmother's grave. And under the roots, lies Ukhokho. This tree saps from her bones. Your great grandmother won't let me sleep until I free them from beneath.

She grabs a large garden fork nearby and attempts to attack the stones with the fork.

JOHN wrestles the implement from her hands.

JOHN: Don't break the floor again, mama!
I'm still paying for damages.

CHRISTINE: They can cover what they've done but the roots keep breaking through. These roots will never go away. Never. Never. Go away.

She is weeping. JOHN helps her to the bench. UKHOKHO slowly withdraws.

CHRISTINE cannot tear her eyes from the apparition. JOHN brings her water, which she gulps.

JULIE drifts in and sits, feet up on the table.

She has put an open bottle of wine on the table and has a glass in her hand.

CHRISTINE: *(Noticing JULIE, she attempts to hide her distress.)* You OK Miesie?

JULIE: I was dumped, Christine. The engagement is off. Everyone knows.

17 **Ma, better not talk of such things.** *(isiXhosa)*

Marrying him was my father's idea anyway. He needs a
man to take over this place. I don't…need a man.

Did you give Diana the muti[18]?

CHRISTINE: Yes mies. I'll check on her now.

CHRISTINE stands.

JOHN: It's OK, ma. I'll do it.

*JOHN helps his exhausted mother to a chair in the corner. CHRISTINE
sits heavily. JOHN helps her settle. She closes her eyes. JULIE watches
them suspiciously.*

JULIE: What's wrong with her?

JOHN: She's just tired, Mies.

JULIE: I asked you to change.

JOHN: What does my madam want me to wear?

JULIE: Whatever you wear when you're not the Help.
Be a man tonight, John. Not a 'boy'.

*JOHN is sharpening a sickle. JULIE has her back to him. He watches
her.*

She senses his gaze and turns.

What are you staring at?

JOHN: *(Caught.)* Just remembering…

JULIE: What?

JOHN: You as a child.

18 medicine *(vernacular)*

JULIE: What do you remember?

JOHN: Things.

JULIE: Tell me.

JOHN: *(Glancing over at CHRISTINE.)* My mother's trying to sleep, mies.

JULIE: Then she should go to her room.

CHRISTINE has fallen asleep in her chair.

Come. Sit.

JOHN: Meneer doesn't like it.

JULIE: It's my table too – and I say: sit!

He doesn't move.

And if I order you?

JOHN: *(Shrugging.)* I'll do it.

JULIE: So sit.

Wary, he moves slowly to the table and sits.

Drink?

JOHN: I have to get up early.

JULIE: Don't make me drink alone, John.

She pours a glass of wine for him.

None of this 'Crackling'[19] poison you guys drink.
The best from my father's cellar.

(Cynically.) To Freedom.

He raises his glass.

Do you feel free?

JOHN: Sure.

JULIE: Good.
Now kiss my foot.

He rises and steps away from the table.

To show just how far we've come in almost twenty years!

He moves back to his bench.

(Viciously.) Fucking. Do. It.

Slightly enraged, he stands and moves to her. He kneels and reaches for her foot. She slips it away from his grasp. In a flash, he grabs her foot and puts it on his shoulder. He runs his hand up her thigh towards her crotch. He runs his open mouth over the top of her foot. She is stunned. And aroused. He moves away.

JOHN: Get out of here, Mies Julie!

JULIE: *(Flustered.)* You afraid?

JOHN: Just go, please.

He is glancing at the windows.

19 *An extremely cheap, poor quality wine that farm labourers commonly drink in South Africa's farmlands.*

JULIE: *(Realizing.)* You worried what the other workers will say…

JOHN: Everyone was already talking, mies.

JULIE: Why do you care?

JOHN: I live with them.

JULIE: I live with them too.

JOHN: No you don't. You live in this house. I live out there.

JULIE: Am I supposed to feel sorry for you?

JOHN: You not supposed to feel anything for me, mies.
You don't know how much bitterness is out there.
Let's just not be alone, ok?

JULIE: We're not. Your mother is here.

JOHN: Sleeping.

JULIE: Then I'll wake her.
Christine. CHRISTINE.

CHRISTINE mumbles in her sleep.

(Roughly.) HEY WENA![20] CHRISTINE!

JOHN: Leave her alone, mies.
She's been working since sunrise.

JULIE: I heard you talking about my ma.
I remember the day she died. You…

20 **You!** *(isiXhosa)*

JOHN: What?

JULIE: Cried. I came out of the church and everyone was
watching me – hungry eyes. You were the only one not
looking. You had your hat in your hands. You were looking
down. Your mouth was trembling. You cried for her.

JOHN: No. For you.

JULIE: *(They stare at each other.)*
Come with me.
I want to show you where I go some nights.

JOHN: No.

JULIE: I'll bring my dad's gun.

JOHN: It's not that. I can protect you.

JULIE: You don't want to be seen.

JOHN: They're stupid with anger, mies. They won't
understand.

JULIE: I respect them more than you do.

JOHN: Times have changed. They don't care if you do.

JULIE: But they do. Respect me.

JOHN: No. They don't. They need you.
And your father. They need a job.
They eat your bread. But they laugh at you behind your
back.

JULIE: That's cruel.

JOHN: And if I walk out there with you – they will laugh at me too. Now I have to walk with you, and laugh with them about you afterwards. I'm not going to do that.

JULIE: You're strong.

JOHN: Yes.

JULIE: Some nights I just want to walk into the Karoo[21]. Like the poet who walked into the sea.[22] Beneath the pylons like huge mothers, arms folded – watching me. Out into the veldt until I reach the Power Station. She used to go there at night. She liked to stand beside it. Listen to it sing. And in my dream I'm there. I start to dig. My fingers are bleeding. Suddenly the hard ground gives way and I am falling. And I want this. To be falling. Do you dream?

JOHN: Every night. I'm a boy again. Reaching into a black eagle's nest to steal eggs. But they keep slipping – covered with salt and stickiness. I manage to get my hand around one. It's still warm. I don't realize it's a black mamba's nest I have my hand in. I feel the bite like a stab into the bone. I know I have minutes before I fall into the black sleep. I always wake up drowning – without air.

JULIE: Come with me. We can go out the back. No one will see us.

He suddenly holds his hand over his eye.

What is it?

JOHN: Mosquito in my eye.

JULIE: Laat ek sien.[23]

21 *A large elevated, semi-desert plateau in South Africa.*
22 *Reference to* **Ingrid Jonker** *(1933 – 1965) an iconic Afrikaans poet who committed suicide by walking into the sea.*
23 **Let me see** *(Afrikaans)*

JOHN: I'm ok.

JULIE: Let me see!

She leads him to sit and steps between his legs to look into his eye. She blows gently into the eye.

CHRISTINE wakes and yawns.

CHRISTINE: Kuqhubeka ntoni?[24]

JULIE: Mosquito in his eye, Christine.

CHRISTINE: Yithi ndibone.[25]

JOHN: Ndiright ma.[26]

CHRISTINE: Let me see.

JOHN: It's ok ma. Go to bed.

CHRISTINE: I have to check on Diana.
The storm is almost here. Even though we've repaired it – the roof is still leaking. Don't forget to put buckets out.

JOHN: Ndizakuzenza ngoku.[27]

CHRISTINE sings softly as she leaves. JULIE steps back between JOHN's legs.

JULIE: I almost had it…

JOHN: You're playing with fire, Mies Julie.

JULIE: Good thing I'm insured.

24 **What is it?** *(isiXhosa)*
25 **Come here** *(isiXhosa)*
26 **I'm ok mama** *(isiXhosa)*
27 **I'll do it now.** *(isiXhosa)*

JOHN: Ja. But I'm not.

He moves to go. She steps in his path, her body against his.

Don't test me, Mies Julie. I'm only a man.

He moves to kiss her mouth. She slaps him brutally across the face. He is stunned. He turns away in rage.

JULIE: Ah come on now. Don't sulk.

He picks up a boot and starts to polish it.

Put the boot down.

He ignores her, seething.

Put it down!
You're proud.

JOHN: No, I'm not! I'm just a groveling kaffir[28] boy – grateful for my job.

JULIE: *(Regretful.)* I'm sorry… Ek's jammer…[29]

He continues polishing.

(Close to tears.) I'm sorry.

They are both emotional and silent.

(After some time.) Have you ever loved a woman?
Have you? I mean like you couldn't eat. Couldn't sleep.

He looks at her.

28 *An offensive South African term for a black person.*
29 **I'm sorry…** *(Afrikaans)*

Who was she?

He looks away in shame. She realizes.

What?
Since when?

JOHN: Your mother came home from the hospital with you
wrapped in a blanket. We were all waiting to welcome
you. Your mother got out the car. Her face empty. No one
behind her eyes. She put you in my mother's open hands
and didn't look back once. Just walked into the shade of
the dark house. My mother put you on the kitchen table.
I stood on a chair to see. I remember the love on my
mother's face when she first unwrapped that blanket.

She never looked at me like that.

Before you could walk – you were always in her arms or
tied to her back.

JULIE: My ma was always on fire about something. Never
about me.

JOHN: We love what our mothers love.

JULIE: And we hate what takes them away.

JOHN: When you were old enough to play with us – the kaffir
kids – your father couldn't keep you away from me. Tried
beating you. But nothing made you ashamed.

JULIE: School. Graaf Reniet taught me that.

JOHN: And your cousins – from Leeu-Gamka[30].

30 *A small town in the Western Cape Province of South Africa.*

JULIE: Hannes and Dirk?

JOHN: They would come every Christmas. They would always call me to play.

JULIE: *(Laughing.)* You were…

JOHN: The 'clever kaffir'. I know. One evening, Hannes is racing me to the swing tire in the willow tree.

JULIE: The rope is still there – rotten now though. It's become part of the tree.

JOHN: I was faster, stronger than Hannes that year. I can hear him swearing behind me. I reach the tire before him and jump in.

JULIE: I remember that year you won. The look on Hannes' face.

JOHN: I swing hard. High.
I know you are watching us from the stoep[31].
I feel something wet and warm on my back. I turn. Hannes has his dick out. He laughing with Dirk. Pissing on my back. I look up at the stoep. You are laughing too. You're beautiful. And cruel.
Then you are gone. Into the house.

JULIE: Childhood is brutal.

JOHN: Only for kaffir boys.

JULIE: No. For everyone.

JOHN: You don't know –

31 **veranda** *(Afrikaans)*

JULIE: I know.

JOHN: Later, I climb the tree by the farmhouse to see you.
I fall and land in the dog shit. The boere men come out
with dogs and guns. When they see it's just me – they start
laughing, kicking me. Your mama is watching from behind
the window. Dark eyes. My mama behind her. Nothing she
can do but watch. I run. I'm crying. I hide in the veldt. You
are out there. Playing alone.

JULIE: I always loved being out there. By that old windmill.

JOHN: You squat behind an aloe to pee. Your dress gets wet.
You take it off and hang it in a tree. Your breasts are just
starting. I lie there in the wet earth – stinking of dog shit –
watching you. Between being a woman and a child…

JULIE: I always felt you.

JOHN: A dog can be your pet. A horse your companion. But
a kaffir boy… What is he? I want to drown myself in the
dam but my uncle fishes me out and beats the shit out of
me. I go home. Mama washes me. We go to church.

JULIE: And then?

JOHN: I decide to die.

JULIE: How old were you?

JOHN: Maybe 14. If I can't have you – I want to disappear into
the harvest. Like I was never born. I wait for the night of
the full moon. I climb inside the silo and wait for morning
when they dump the new load. But my uncle follows me.
He lets the grain fall and bury me. Just as I stop breathing
– he pulls me out. To teach me a lesson. I vomited dust and
blood for weeks.

JULIE: Jussis.[32]

JOHN: Have you ever been loved like that?

JULIE: You loved me?
 Or you just hated yourself?

JOHN: Same thing.

They both smile.

JULIE: You different.

JOHN: I read.

JULIE: What do you read?

JOHN: Whatever I get my hands on. I'm not going to spend
 my life cleaning your father's boots.

JULIE: So what's the plan? It's a free country.

JOHN: I have a plan.

JULIE: Hoping for a hand out? Some land so that one by one,
 the farmlands return to black hands?

JOHN: Maybe.

JULIE: It's not some score to be settled, John. Farming is a business.
 And a tough one.

JOHN: Don't worry about me, mies.

JULIE: I worry about *me*. And my father. Here. The dogs were
 barking again last night. That low growling that wakes you
 up in the dark – breathless. Because you know someone

32 **Jesus.** *(Afrikaans)*

who shouldn't be – is near. Some nights I go stand outside.
I feel safer there. I sleep with my gun under my pillow.

JOHN: I know.

You need to get married, Mies Julie.

JULIE: What for? Someone comes in here to kill us – we both
going to get a panga in the head. Why suffer marriage, if
he can't even save me?

JOHN: Why did you push him away like that?

JULIE: He was afraid.

JOHN: Women always say that, when a man doesn't love them.
Why can't they just say: He doesn't love me?

JULIE: Why can't men just say: I'm afraid?

JOHN: Of what?

JULIE: Everything. Mostly of women who love them.
You're such cowards.

JOHN: I'm not afraid.

JULIE: How many women do you have?

JOHN: Enough.

JULIE: If you were not afraid – you wouldn't need more than
one.

JOHN: I saw you in the stables with him.

JULIE: Spying on us.

JOHN: It was too late for me to leave. I saw you go down. Your nose bleeding. On your knees. Crying. But strong.

They are so close, their bodies are touching.

JOHN: *(Pulling back.)* I'm going to bed.

JULIE: *(Catching his hand as he turns to go, she pushes him into a chair.)*
It's Freedom Day out there, John.

She lifts her skirt slowly. He watches. She straddles him.

He grasps her to him, overcome with desire. Suddenly, he pushes her off.

JOHN: This is just a game to you. But my mum and I – we have nowhere else to go. She was born on this farm. Her sweat is in these walls. Her blood – in this floor. Now I must risk everything.
Because you're drunk and bored tonight.

JULIE: It's just a walk. I'm not asking you to marry me.

JOHN: I wouldn't – even if you asked!

She moves to strike him again. He grabs her wrists.

Slap me again – you better be ready.

JULIE: For what?

He shoves her at the table and tears her dress away.

JULIE: *(Vulnerable, panicked.)* What if the others come in?

JOHN: I'll kill anyone who comes through that door.

He pushes her flat onto her back on the kitchen table, tears away his overalls and penetrates her. She cries out. Realizing the gravity of what he is doing, he stumbles away from the table overwhelmed. He cannot stay away. He jumps onto the table. He lies on her and she embraces him. He fucks her hard. She weeps, overcome with emotion. He comes. They kiss passionately. Then tenderly. He whispers to her. JOHN falls asleep in JULIE's embrace. Light moves across the kitchen floor, as the hours pass. Thunder rumbles.

And while they are sleeping, CHRISTINE & UKHOKO rise from where they have been waiting on the periphery, and stand over the table, watching them. They sing in unearthly tones, with farming implemets over their shoulders. Is this JOHN's dream or a visitation? We will never know. They move across the room as they sing. CHRISTINE places tin buckets around the room to catch the water dripping through the roof. UKHOKHO lifts the Meneer's boots and places them centre stage. The women move away. CHRISTINE tips the birdcage as she leaves. It is still spinning like a small house in a storm as…

2.

JULIE wakes abruptly. It is still dark out, but morning will break soon. She sees JOHN sleeping beside her. She looks between her legs. There is blood on her thighs. Breathless with realization, her eyes scan the room. She gets off the table and walks the kitchen – looking at everything as though new. She sees her father's boots and buckles with fear and pain. She squats over a bucket and cleans her inner thighs. JOHN wakes and watches her.

JOHN: *(Gently.)* You OK?

> *She turns her naked body away and, finding JOHN's 'throw' nearby on the floor, she hangs it around her neck – covering her breasts.*

I was your first?

> *She nods. He pulls her into his embrace.*

You mine now.

JULIE: You love me? *(JOHN is silent but not unloving.)*

Say it.

JOHN: Not in this house. While those boots wait for me, mies.

JULIE: You call me 'mies'. After last night? *(She laughs softly through her tears.)*

JOHN: Habit.

JULIE: Break it.

JOHN: While we are still in this house – my skin, my hands belong to him.
Just looking at those boots makes my stomach hurt.

JULIE: You mine now. Not his.

JOHN: Not here.

JULIE: So let's leave.

JOHN: Now?

JULIE: I can't stay.

JOHN: I can't go.

JULIE: Why not?

JOHN: I can't leave my mother.

JULIE: You deserve your own life.

JOHN: That's not how it works for us.

JULIE: It's not how it works for *any* of us. But we have to make our own lives!

JOHN: Where would we go?

JULIE: Who cares, John? Let's just go.

JOHN: We both belong to Veenen Plaas. We'll drown out there.

JULIE: You said you had a plan.

JOHN: I do. But I can't leave my mum here.

JULIE: OK. So we take Christine with us. To the city. We – I don't know – start a hotel. Buy an old house and fix it up. I've always wanted to do that. Make something old and ugly – new. I'll deal with the guests. You can fix things. Christine runs the kitchen and makes the beds. We could

be a place with a story: The couple that ran away from Veenen Plaas.

JOHN: It's a beautiful story. *(Indicating the sign over the door.)* 'The Weeping Farm.'

They laugh.

JULIE: What are we staying for? A pair of boots to polish and an ancestor beneath the floor? My father's already got his grave marked out next to my ma. And his parents. And theirs. All the way back to the Voortrekkers[33]. There's a spot reserved for me too – but they can give that red dust to someone else. What are we staying for? Graves and soil?

JOHN: My mother wants to be buried here. She will never go.

JULIE: Then you must go without her. You're a man now, John. Not a boy.

JOHN: *(Possibility is growing for him.)* How much for an old house?

JULIE: How much do *you* have?

JOHN: Me? *(Laughs, stunned that she can even ask.)* I still owe your father my next three wages. From when mum broke the kitchen floor.

JULIE: John, *I* don't have anything. Until my father dies – I don't even own this land.

CHRISTINE enters the kitchen. JOHN and JULIE scatter – scrambling for clothes.

33 **pioneers** *(Afrikaans for 'those who go ahead'). Emigrants during the 1830s and 1840s who left the British Cape Colony, migrating into the interior Highveld, north of the Orange River in South Africa.*

CHRISTINE has a spade over her shoulder and a bucket in hand, filled with blood. She wears a torch tucked into her plastic apron and a shawl about her shoulders, against the dark morning cold. She watches them silently as they fumble with buttons and zips.

CHRISTINE: *(When they are still, she pours the blood into a nearby bucket.)* Diana is finished now miesie. I buried the puppies out beyond the field. By the windmill. I got up to do it before sunrise. With this heat…they would rot fast out there. Still no rain. Just light drops that mark the dust and make this old roof leak.

Looking out across the skies.

(Inscrutably.) Some children living in the karoo have never seen rain. They've seen the clouds roll in from the Kalahari, and they've heard the gysie[34] sing for three days. But nothing. Never seen a storm. It can bewitch you – the endless promise of rain.

Try to get some sleep, mies. I'll wake you when your father gets here.

Addressing her son.

Wena![35] I'll press your suit for church.

They are alone again. JULIE watches JOHN, who is pacing, mortified.

JULIE: John, what are you thinking?

JOHN: I'm thinking –
I have boots to clean.

JOHN picks up the boots and begins to polish.

34 *A small field cricket, common in the karoo, that is known to sing for up to three days prior to rainfall.*

35 **You!** *(isiXhosa)*

37

JULIE: We have to go. My father will be home soon.

JOHN: We're staying.

JULIE: We can't stay. Everything has changed.

JOHN: Nothing has changed. *(Bitter.)* Welcome to Mzantsi[36], Mies Julie. Where miracles leave us exactly where we began.

JULIE: But…you love me.

JOHN: *(Cold.)* So what?

JULIE: Since I was a girl. My dress in the tree. Me in a blanket. You drowning in the grain.

JOHN: You liked that. That I wanted to die for you?

JULIE: Yes.

JOHN: Why?

JULIE: Because I'm a woman.

JOHN: A boer – who wants my black skin on a wall.

JULIE: Don't do this.

JOHN: I can't help myself.

JULIE: Don't be cruel.

JOHN: You like it.

JULIE: You hate me.

36 **South Africa** *(from the isiXhosa word 'uMzantsi' meaning 'south'.)*

JOHN: No, Mies Julie. I don't hate you. You're a detail.

JULIE: You love me.

JOHN: I lied.

JULIE: The grain silo?

JOHN: Read it in a book by an Afrikaans poet. You people like sacrifice. As long as it's someone else's blood.

JULIE: You have no idea what love is.

JOHN: And you do? Your mother couldn't stand looking at you. Your father knows only the fist and the boot. The only love you've ever known is from the tired black hands of my mother.

JULIE: Jealous?

JOHN: No. I'm angry. There's a difference.

JULIE: Well grow the fuck up, John.

JOHN: *You* – can't even cook yourself a meal.
You depend on us for everything. We clean up your shit. Run your kitchens. Raise your children. Plough your fields. But still – like a child – you want.

JULIE: What? What do I want? Your stinking poverty? Your desperation?
Your rags?

He turns to leave. She runs after him.

JULIE: *(On her knees, her arms around him.)*
Please.

Please.

He shakes her off. She grabs him.

JOHN: What do you want from me?

He kisses her violently. She responds. He throws her to the floor, and sits.

Say it! What do you want?

She crawls to him, weeping, grasping at him. He lifts her to him and kisses her again. He throws her to the ground and stands. He kicks open her legs.

You want this?

He pulls her to her feet and shoves her – face first – over the table. He pulls her dress up, pushing himself into her brutally from behind.

This? You want this?

JULIE: *(Weeping.)* Yes! I want it.

He zips up and walks away. She is weeping.

Jou vokken vark![37]

JOHN: You don't get what you want anymore.
That's what has changed. There's freedom in that for both of us.

JULIE: Ek verstaan nie.[38]

37 **You fucking pig!** *(Afrikaans)*
38 **I don't understand.** *(Afrikaans)*

JOHN: Since I was a boy – going hunting with your father at dawn, carrying his gun, being his 'best boy' – I've watched him take what he wants and still behave like he's owed.

JULIE: John, I'm just a boer –

JOHN: …With nothing on the table, who now wants to cut a deal.

(She spits in his face.)

JULIE: A kaffir! Who will do anything to get his hand in the jar.

JOHN: And I liked getting my hand in the jar. Making you bleed. *(Shoving his hand between her legs.)*

This is my blood covenant, Voortrekker Girl. Running down your thigh.

He grabs the wine and drinks straight from the bottle.

JULIE: That is my father's best wine. When he finds out…

JOHN: What? That I fucked his daughter? Or drank his wine?

JULIE: A kaffir will always be a kaffir.

JOHN: And a bitch will always be a bitch.

JULIE: I can't believe I let you touch me.

JOHN: I didn't touch you. I fucked you! You're full of my seed. A harvest I planted for the future last night.

He sits at the table with his feet up.

Tell me, Mies Julie. What if you're carrying my child?

She drops to her knees in horror.

Then this land will return to the rightful owners.

JULIE: So this… This is your revenge?

JOHN: No!
This is restitution.
Of body and soil.

JULIE: My God. Wat is jy?[39]

JOHN: A man. With a plan.

JULIE: Be careful. The nest you have your hand in, is a black mamba's.

JOHN: You're not a snake. You're the past. A sad, empty-handed boer still trying to be powerful.

JULIE: And you are just a KAFFIR! STAAN OP WANEER JY MET MY PRAAT – JOU FOKKEN PLAAS KAFFIR![40]
· You'll never be anything but a kaffir. Good for cleaning boots.

(She weeps for sometime. He watches her.)

I could have loved you.

JOHN: You don't love me. You never will.

JULIE: Why not?

JOHN: Because love is not possible in this mess.

39 **What are you?** *(Afrikaans)*
40 **Stand up when you are talking to me, you fucking farm kaffir!** *(Afrikaans)*

JULIE: What if I do? What if I have since I was a girl?

(She holds him. He yields. They hold one another. He pulls away.)

JOHN: Stop it!

JULIE: Why?

JOHN: You want me dead. I will not die for you.

JULIE: I love you. I believed you when you said you do.

JOHN: I did.

JULIE: When did you stop?

JOHN: When you gave yourself to me.
 This morning – when I saw my mother's trembling hands.

JULIE: Why? Why does it have to be like this?

JOHN: I don't know, Julie.

JULIE: We're all so scared.

JOHN: Yes.

JULIE: Hit me.

JOHN: What?

JULIE: Hurt me. Please.

JOHN: No.

JULIE: HIT ME.

She beats her arms, her face – savagely. He grabs her.

JOHN: Stop! Julie stop!

She weeps. He holds her. He whispers.

I'm sorry. I'm sorry.

JULIE: *(Pushing him away.)* Pour me a drink.

He does. She grabs the bottle from his hand and chugs.

My ma always tried to fit in here with the other boere[41] tannies. But they were always harder, crueler. Having their hair and nails done on Fridays like they were going to battle. If you are sensitive out here in this arid land – you don't make it. They often found her in her nightie – standing by the power station – listening in the dark. My father told me once that's what killed her. She listened. To what's beneath. If you're tender out here – you drown.

She gulps more wine from the bottle. JOHN pulls it away gently.

JOHN: Don't drink anymore, Julie.

JULIE: He lost patience. She would hit him. And sometimes he would hit her back. Those were the mornings she would come to breakfast looking calm. With bruises from his fists. My ma was always elsewhere.

JOHN: My mother was always with you.

JULIE: I know.

I love this farm.
It's all I know.

41 **farmer's wives** *(Literally, Afrikaans for 'aunties' but connotes 'wives' here)*

JOHN: What do you love?

JULIE: Everything. The space. The silence. When I was sent to boarding school – I thought I would die.

JOHN: It's not yours to love.

JULIE: Says who? What makes it less mine than yours? Your black skin?

JOHN: My people are buried here. Beneath this floor.

JULIE: So are mine. Out there beneath the willow trees. Three generations back. Where the fuck do I go?

JOHN: That's not my problem.
 They stole it.
 Your people.

JULIE: Fok jou.[42] So did yours. From the First here.
 How far back do you want to go?

JOHN: Let's just say your people did things to keep it that can never be excused.

They are both silent.

Love me, Mies Julie. Love the land. Love that old windmill out there. But we will never be yours.

JULIE: A boere tannie once threw hot soup at her for saying we don't belong here. She just laughed. Said when people turn violent – you know you've told the truth. There's something to be said for violence. Lets you know where you stand.

42 **Fuck you.** *(Afrikaans)*

JOHN: That's why you hit Baas Jan with the sjambok[43]?

JULIE: What did you see that day?

JOHN: You on your knees. Him forcing himself like an animal into your mouth. Did that feel honest?

JULIE: It was his finest moment.

JOHN: Why?

JULIE: He was being true.

JOHN: You hate yourself, Julie.

JULIE: No, John. I hate you.

JOHN: Why? You have everything of mine.

JULIE: I have nothing. Don't you see?

JOHN: Mother.
 Body.
 Land.

JULIE: Die with me.

JOHN: Die?

JULIE: Let's start new.

JOHN: I'm going to bed. Turn the light off when you leave.

He turns to go.

JULIE: Not so fast, fucker! You owe me.

43 *A whip of cured leather, capable of inflicting great pain and damage to the skin.*

JOHN: Owe *you*?

JULIE: You don't use me and throw me away like that.

JOHN: You boere. You take and take. But when something is taken – you want to burn the house down. You complain what a mess everything is out there. Who made the fucking mess? The party is over. We'll clean up your shit as usual. Just go.

JULIE: Where? This is my home. My great grandfather built it with his bare hands.

JOHN: Your great grandfather was a squatter. Take this shack and build it somewhere else.

JULIE: A squatter? Is that what you just said?

JOHN: He who moves onto open land to gain title. I read. Remember?

JULIE: Tell that to my father.

JOHN: He cries war on those doing exactly what your ancestors did.

JULIE: We own the deeds to this land.

JOHN: From whom? The man who first took what never belonged to him?

He makes for the door.

JULIE: Walk away and I will scream rape.

JOHN stops dead in his tracks.

I am full of your seed. I have evidence. I bled.

JOHN: Of course – this is where desire ends. The white daughter crying rape on the black man. So that her father can accept her fucking him.

JULIE: You will be in jail by tonight if he does not put a bullet in your head first.

JOHN: Remember – your father promised you a bullet in the head too. So here we are: Two kaffirs. Doomed to die.

JULIE: I don't know how to be anymore.

JOHN: I know.

JULIE: I need you, John.

JOHN: I don't need you, Julie.

JULIE: Yes – you do.

I may be carrying your child. If I disappear – you are back to cleaning boots.

They are both silent.

My father has money in his safe.

JOHN: And a gun. I know.

JULIE: I know the code to the lock.

He looks at her.

(Her hand on her belly.) Let's go until the storm passes. Maybe we can return someday with a child who walks with all our ancestors in the shadows – who lay claim to Veenen Plaas.

JOHN: Go. Get what we need.

JULIE: You'll come with me?

JOHN: Get what we need and come back here.

JULIE: Speak kindly to me.

JOHN: This is what orders tastes like. What we swallow
everyday. Go.

*JULIE exits. JOHN sits with his head in his hands. CHRISTINE enters.
She is immaculately dressed in her Church uniform. She holds a Bible
in her left hand, and JOHN's suit on a hanger in her right. She lays
the suit flat on the table.)*

CHRISTINE: Get ready for Church.

JOHN: I'm tired.

CHRISTINE: Too tired for God?
Look at me.
LOOK AT ME!

She suddenly slaps him brutally in the face.

What have you done? We have nothing. Nowhere else to
go!

JOHN: Mama, there is more! More to life than slave wages and
scrubbing a floor!

CHRISTINE: Is that so?

JOHN: Why just accept?

Why accept scrubbing that floor for the rest of your life?

Freedom is not worth shit! As long as we must pay honour to ancestors that bind us to this dead land where nothing grows!

She holds up her hand in front of him – palm and fingertips facing toward him. She is silent.

What is it, ma?

CHRISTINE: No fingerprints.

JOHN: What?

CHRISTINE: When I went to vote for the first time – 18 years ago – they needed fingerprints for identification. But they're gone. I lost them. Rubbed them smooth, cleaning this floor! These walls! That child!

JOHN: Ma –

CHRISTINE: They told me they would make a plan for me. Said there were other maids with the same problem. No identity. But I never went back. What's gone is gone, and can never be reclaimed.

JOHN is silent. He covers his face with his hands. He feels like he may weep and it will never end.

Now get dressed for church. And when we come back – there is work to be done.

JOHN: I want more, ma. I want what belongs to us.

CHRISTINE: Our jobs belong to us. It's more than most people have. Do the boots. Be grateful. Get dressed. Go to church on Sundays.

As long as those bones lie beneath this floor – that's how we get to stay near our ancestors on this land.

I'm waiting outside.

CHRISTINE exits. UKHOKO is slowly circling the periphery, watching JOHN – who agonizes over this decision. He removes his gumboots and puts the jacket from the suit on. Upstage, as though outside the kitchen, JULIE takes down the birdcage and tenderly covers it with fabric.

JULIE: Ek's reg.[44]

(She has entered holding a small bag, the shotgun strapped to her back and the birdcage.)

JOHN: You're a mess.

JULIE: How?

JOHN: Your face is dirty.

JULIE: *(Rubbing her face.)* Die son is op.[45]

JOHN: How much do you have?

JULIE: Enough.

JULIE puts the rifle and the birdcage on the table.

JOHN: What is that?

JULIE: My bird. I can't leave her behind.

JOHN: We can't take it. Are you mad?

44 **I'm ready.** *(Afrikaans)*
45 **The sun is up.** *(Afrikaans)*

JULIE: I'd rather she were dead than alone.

JOHN: Give it to me. I'll do it.

JULIE takes the bird out of the cage and kisses it tenderly.

JOHN grabs it and crushes it in his hands. JULIE screams. He throws it in the nearby bucket.

JULIE: *(Devastated.)* I'd like to see your blood and brains on a wall.

CHRISTINE enters – Bible in hand.

JULIE: Hold me, Christine. Like when I was small.

CHRISTINE: *(Cradling her.)* Sssh. The storm is breaking. There will be rain coming soon.

JULIE: We must run away before my father gets home.

CHRISTINE: I cleaned the blood off these walls myself. The madam sat in this chair. Sunday morning. Put the master's rifle under her chin. You found her here in this kitchen.

Came running to get me from the veldt. You kept asking me what you had done wrong. I said: 'Nothing, little one. It's not your fault. It's not your fault'.

JULIE: Christine. Me and John are going away to open a hotel. Will you come with us, ma?

CHRISTINE looks at JOHN stunned.

CHRISTINE: I'm going nowhere. Except to church. And then home to clean this house.

JULIE: Christine – we could be a family.

CHRISTINE: *A family?* You *believe* that, mies?

JULIE: I don't know, Christine. I don't know what I believe anymore.

JOHN: Ma – I was never going to leave you.

CHRISTINE: You were going to do what?

JOHN: Take back what belongs to us.

CHRISTINE: You disgrace your ancestors.

JOHN: *(A cry from his soul.)* Mama, I'm tired of waiting!

CHRISTINE: What do you know about waiting? You were born ten minutes ago.

JOHN: *(Brutally.)* You are going to keep scrubbing that floor until you die.

CHRISTINE: I will wait. Until this house turns to dust. Until this floor turns to sand. Until the waters rise and it all floats away. I can't break it open and set them free. I have tried. So I wait. These roots are my hands. And beneath these stones – my blood is warm.

JOHN: We take it back ourselves. Or we leave.

CHRISTINE: Get ready for church.

JOHN: They took our land and handed us the Bible.

I'm not going to Church. Ever again.

He grabs her Bible and throws it brutally. CHRISTINE drops to her knees, broken. She holds the Bible. She rises and tries to compose herself.

CHRISTINE: I will meet you there when you are finished with this mess.

I trust you, my boy.

CHRISTINE leaves. JOHN is sitting on the floor, devastated.

JULIE: Can you see a way out of all this? An end for the whole thing?

JOHN: *(He can barely speak.)* Go. There's no other way.

JULIE: I've nowhere to go.

JOHN: Then stay and fight. You will lose.

If you are lucky – my child is in your womb and your children will have a place on Veenen Plaas.

In one move – she grabs the rifle and has it pointed at JOHN's head.

JULIE: You think I love you, Kaffir boy? That I'm going to carry your black child under my heart. Feed it with my blood? Give it your name? Wash your socks and underpants; cook your food; raise your children? Be your kaffir! And when my father dies, your black child inherits this land? Is that what you had in mind?

JOHN: It's a good deal. More than your children deserve.

JULIE: You have no capital. No skills. You're a slave.

JOHN: Yes. I have nothing. That's the legacy your people leave.

A nation of grown men and women – good for nothing but cleaning boots.

JOHN seizes the gun.

But it will be our boots we clean. On our own land.

JULIE scrambles for the sickle JOHN was sharpening the night before.

JULIE: I will die before I let you take this Farm.

They square up. Gun and sickle.

JOHN: So here we are.
Free at last.
No longer master and slave.
Just two people in a kitchen.
Fighting for our lives.

She drops to her knees. He has the gun aimed at her head.

JULIE: The Valley of Desolation. That's where I would run to in the mornings. After she died. Standing at the foot of all that rock. Volcanoes and erosions made it over millions of years. Before any of us were here.

Raising the sickle.

I'm a Boer, John. We don't go down without a fight.

JOHN: I can't save you from yourself, Julie.

JULIE: I haven't got a self. I haven't got a thought I don't get from my father. I haven't a passion I didn't get from my

mother. So how can it be my fault? Who is responsible for the wrong? What does it matter to us who is?

JOHN: Julie…

JULIE: You think my body your restitution? My womb your land grab?

JOHN: You don't even know if that child exists.

JULIE: But if I love you again, John – it will. And I'm not taking any chances. Here is *my* blood vow.

She pushes the sickle between her legs, and thrusts the blade upwards into her womb.

A gush of blood. He grabs her.

JOHN: Julie!

He cradles her and carries her to the table. He continues to hold her. She is bleeding profusely.

JULIE: There is mist over the valley in the morning when I wake. It smells like fire. And I realize it's smoke.

JOHN: Julie…

JULIE: Everyone is crying. They are going farm to farm. Burning our fields. Our homes. Scorching the earth. We stand. In silence. Ash in our hair as our farms burn.

JOHN: These memories are not yours, Julie.

JULIE: In the Camps, I watch my children fade and fly away. I bury them at night when no one can see me cry. They sing. The dead children. Welcoming each other through the night.

JOHN: These memories…

JULIE: Are buried out there beneath the willows.

Bury me with them. In the red earth.

Ssh! He's here. Outside.

She is dead. The fan stops turning. He holds her. He tears open her dress and weeps into her breasts. He falls to his knees.

He sits at the table, head in hands. He stands suddenly, panicked. He covers JULIE with his scarf.

He moves to the boots he has been polishing all his life. He puts them on.

He picks up the gun in his right hand and the sickle in his left.

He lowers his head for a moment – overcome.

JOHN: It's easy.

He steels himself.

Just pretend you're him.

Lights shift.

CHRISTINE is alone, on her knees, cleaning the blood off the floor.

UKHOKHO sings and plays her traditional Xhosa bow.

Lights fade – until nothing but the tree stump and roots remain.

Ends.